AUBREY
BEARDSLEY

PATRICK BADE

Publishing Director: Jean-Paul Manzo
Text: Patrick Bade
Design and layout : Sébastien Ceste
Cover and jacket : Sébastien Ceste

We would like to extend special
thanks to Mike Darton for his invaluable
cooperation

© Parkstone Press Ltd, New York, USA, 2001
Printed and bound in Hungary
by Pauker-Printself
Corporation, 2001.
ISBN 1 85995 830 3

The reputation of Aubrey Beardsley has never quite recovered from his brief association with the great Anglo-Irish writer and gay martyr, Oscar Wilde. Wilde claimed to have 'invented' Beardsley, but after his initial kindly if slightly patronising interest in the talented boy, their relationship soon settled into a war of barbed witticisms and bitchy put-downs. When Wilde bought a copy of the first issue of *The Yellow Book* (from which he had been excluded on the insistence of the ungrateful Beardsley) at a railway bookshop, he was so irritated by Beardsley's illustrations that he threw the book out of the train window. One cannot help wondering what any rural passer-by in Victorian England who picked up the discarded volume, with its striking yellow and black cover, would have made of the exquisite perversities of Beardsley's illustrations and the mannered elegance of Max Beerbohm's prose in his essay 'A Defense of Cosmetics'.

Like Wilde, Beardsley has become an icon of the *fin-de-siècle* that neither would outlive. More than any other visual artist in the Anglo-Saxon world Beardsley represents everything that the term *fin-de-siècle* stands for. *Fin-de-siècle* is a term that means so much more than its literal translation of 'end of the century'. It has connotations of bejewelled elegance, preciousness, decadence, perversity, sexual deviation and ambiguity, and of rebellion against the materialism, positivist philosophies and moral certitudes of the mid-nineteenth century.

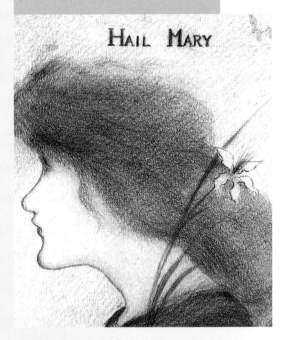

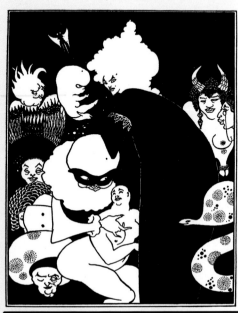

BEARDSLEY
IN BRIGHTON

A ubrey Beardsley was born on August 21, 1872 in the seaside resort of Brighton, south of London. He was the son of the feckless and tubercular Vincent Paul Beardsley and his wife Ellen (née Pitt, and popularly known as the 'bottomless Pitt' because of her slender figure). Ellen Pitt was a woman of social and cultural pretensions, aggrieved to have married, as she thought, beneath her, and to be forced to work as a teacher in order to support her two children, Aubrey and his elder sister Mabel. She was determined to instil in her children a love of the arts and to develop precocious talents from the earliest possible age.

1. Aubrey Beardsley, *Hail Mary*, 1891. This drawing was among those that he showed to his publisher friend J. M. Dent, when the latter was seeking an illustrator for a projected edition of *Le Morte D'Arthur*.

2. Beardsley, Lucian's Strange Creatures, for *Lucian's True History* (not used).

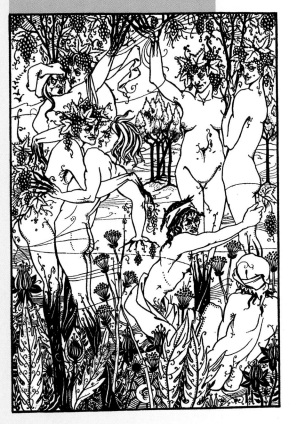

Brighton itself was not without its attractions and stimulations. A noted centre for the sleazy boarding-house, the adulterous weekend and the arranged divorce (as celebrated in Evelyn Waugh's novel A *Handful of Dust* and *Cole Porter's* musical *The Gay Divorcee*), Brighton has an enviably louche reputation, second only to that of Paris in the English imagination. It is a fair indication of the laissez-faire morality of Brighton, that Degas' painting *Absinthe*, which caused such a scandal when it was exhibited in London in the 1890s, was first exhibited at the Brighton Pavilion on loan from a Brighton citizen as early as in 1876 without anyone's apparently raising so much

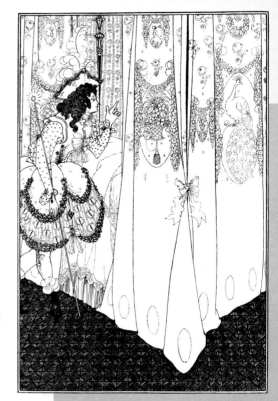

as an eyebrow. While it would appear unlikely that even the culturally voracious and unpuritanical Mrs Beardsley would have taken her infant son in his push-chair to admire one of the nineteenth century's most notorious images of urban depravity and degradation, it does seem a nice coincidence that the people of Brighton were the first to see a picture that would later be echoed in several compositions by Brighton's most famous native artist. Beardsley would also make a very characteristically tongue-in-cheek tribute to Degas with a caricature of Queen Victoria as a dancer in a tutu, on which he inscribed the name Degas.

3. Beardsley, The Snare of Vintage, from *Lucian's True History.*

4. Beardsley, The Morning Dream. Ariel warns Belinda that the day is to bring disaster, from *The Rape of The Lock,* 1895–96.

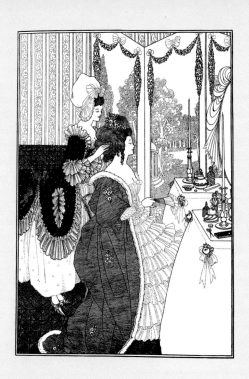

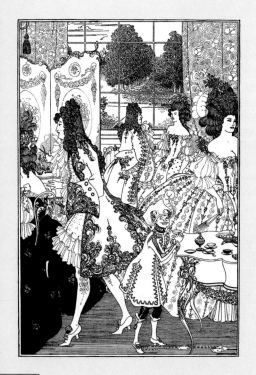

5. Beardsley, The Toilette by which Belinda prepares for the day's festivities, from *The Rape of The Lock*.

6. Beardsley, The Rape of the Lock, for which the Baron makes use of Clarissa's scissors, from *The Rape of The Lock*.

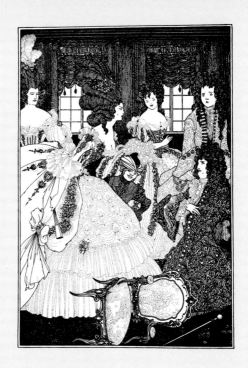

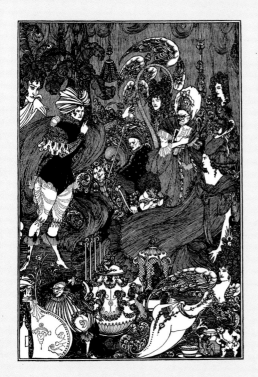

7. Beardsley, The Battle of the
Beaux and Belles. Wrathful
at the loss of her curl,
Belinda invokes a near-
scuffle, from *The Rape of
The Lock*.

8. Beardsley, The Cave of
Spleen. Umbriel descends to
the underworld to find fuel
for Belinda's anger at the
loss of her curl, from *The
Rape of The Lock*.

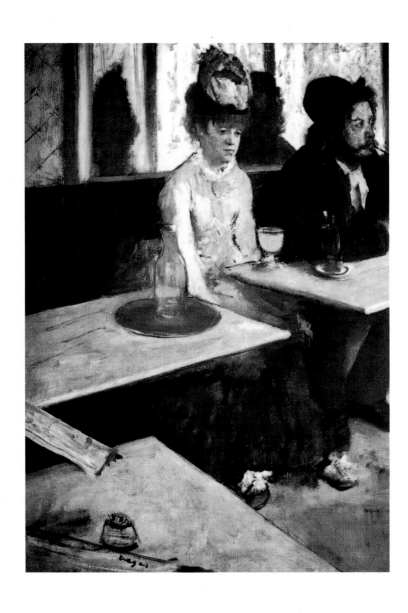

9. Edgar Degas, *In a Café*, also called *The Absinthe-Drinker*, 1875–76. Oil on canvas, 92 x 68 cm. Musée d'Orsay, Paris.

Other aspects of Brighton that left their mark on Beardsley's imagination were the orientalist interiors of the Brighton Pavilion – the fantastic pleasure-palace created for that most amiably debauched of British monarchs, George IV – and the Pre-Raphaelite windows and High Anglican pieties of the churches that Aubrey and Mabel Beardsley visited as a means of escaping the dreariness of life with a maiden aunt who took them in for a while when Ellen Beardsley found herself unable to support her children.

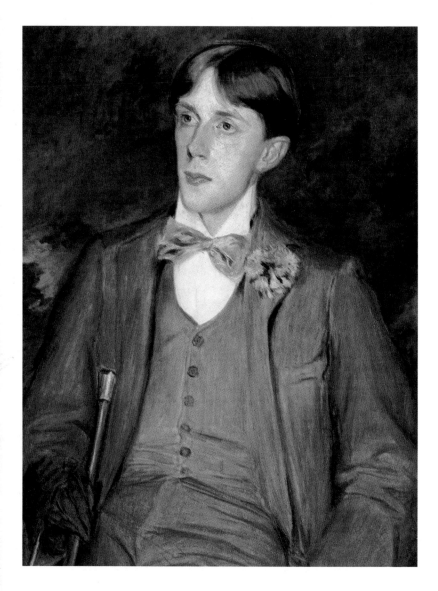

10. Jacques-Emile Blanche, *Aubrey Beardsley*. Oil on canvas, 1895. National Portrait Gallery, London.

Artists of the *fin-de-siècle* such as

PREY TO
CONSUMPTION

Beardsley was seven years old when the first signs were detected of the tuberculosis that was eventually to kill him. From this moment onward, every aspect of Beardsley's life and art was determined by the immutable fact of his illness and the inevitability of an early death. It was this more than anything else that made him such a characteristic figure of the *fin-de-siècle*. Artists of the *fin-de-siècle* such as Beardsley, Toulouse-Lautrec and Munch wore their sickness as a badge of honour. Munch, whose family was devastated by tuberculosis, boasted that 'sickness, insanity and death were the black angels that hovered over my cradle and have since followed me throughout my life.' He strongly contended that illness was a cherished part of his inspiration. 'I must retain my physical weaknesses: they are an integral part of me. I don't want to get rid of my illness, however unsympathetically I may depict it in my art.' Ironically, despite emotional and physical excesses in the 1890s that might have killed even the healthiest of men, Munch confounded all expectations by living into a vigorous old age and eventually dying of a chill aged 81.

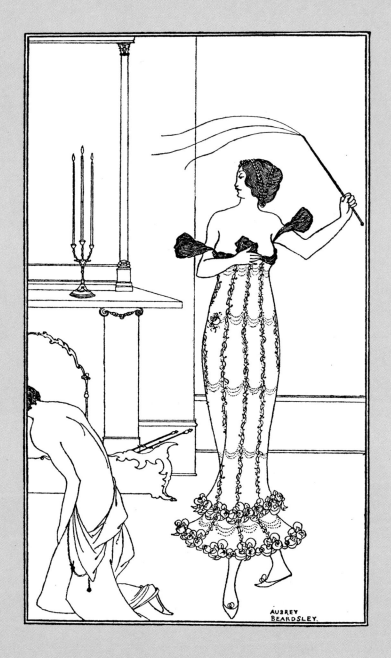

11. Beardsley, frontispiece to *A Full and True Account of the Wonderful Mission of Earl Lavender.*

Beardsley was not to be so lucky. He died in the spring of 1898, half a year before his twenty-sixth birthday. Perhaps no artist since Masaccio – who determined the way the West saw and depicted space for the next four hundred years, before dying at the age of twenty-seven – had had such an impact in such a short life.

The fragility of Beardsley's appearance was remarked upon by everyone who met him. He described himself with brutal frankness when still only a teenager. 'I am now eighteen years old, with a vile constitution, a sallow face and sunken eyes, long red hair, a shuffling gait and a stoop.' Rather than any of his self-portraits or the many photographs of him, the image that captures his fragile appearance most poignantly is an oil sketch that Walter Sickert made from memory of Beardsley wending his way between the gravestones of Hampstead church after attending the ceremonial unveiling of a bust to the Romantic poet Keats in 1894. With uncanny prescience Beardsley predicted that he would not live longer than the poet, and indeed both Keats and Beardsley died at the age of 25.

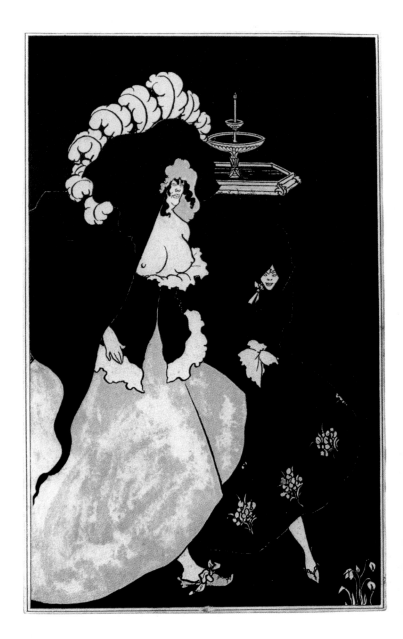

12. Beardsley, Messalina Returning Home.

One of Beardsley's early collectors and biographers, Haldane MacFall, perceived a link between Beardsley's illness and his preoccupation with the erotic, or as MacFall put it, 'that erotic mania so noticeable in gifted consumptives'.

The connections between genius and sickness, and in particular between the innovations of modern art and physical and mental infirmity, were intensely discussed in the last decade of the nineteenth century. One of the most controversial and influential books of the 1890s was Max Nordau's *Degeneration*, published in 1893, the year that Beardsley shot to fame in the pages of *The Studio*. As George Bernard Shaw neatly summed it up, Nordau's 'message to the world is that our characteristically modern works of art are symptoms of a disease in the artists, and that these diseased artists are themselves symptoms of the nervous exhaustion of the race by overwork.' It is deeply ironic that Nordau, who was Jewish and a pioneer of Zionism, should with his ludicrous pseudo-science have provided a basis for later Nazi denunciations of modern art.

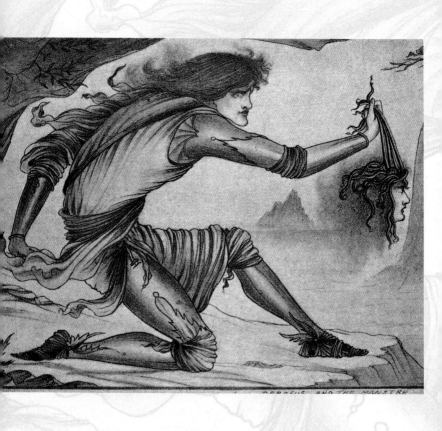

13. Beardsley, *Perseus and the Gordon's Head*, 1891.

BEARDSLEY AND
BURNE-JONES

In 1888 – the *annus mirabilis* of early modernism, in which both Van Gogh and Gauguin made their most significant breakthroughs – Beardsley (still only fifteen years old) began work as a surveyor's clerk in London on the meagre salary of £70 a year. At this stage, it was far from clear in which direction Beardsley's inclinations would take him. Throughout his life he would entertain literary as well as artistic ambitions. The decisive event was a meeting with the Pre-Raphaelite painter Edward Burne-Jones in 1891. On a hot summer's day, Beardsley and his sister Mabel turned up on the doorstep of Burne-Jones's Fulham house hoping to see his studio. Initially they were turned away by a servant, but as they walked away disconsolately the artist chased after them and invited them not only to see the studio but also to take tea on the lawn. This was also the occasion when Beardsley first met the man who was to have such a baleful effect on his destiny, Oscar Wilde. Wilde and his wife Constance drove Beardsley and Mabel back home in their carriage and were described by Beardsley in a letter shortly afterwards as 'charming people'.

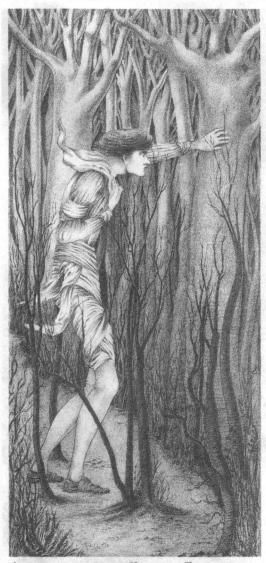

HAMLET PATRIS MANEM SEQUITUR.

14. Beardsley, *Hamlet Patris Manem Sequitur*, 1891.
 Lithographic facsimile of a drawing from *The Bee*,
 November 1891. This is Beardsley's first published design.

Beardsley took the opportunity to show Burne-Jones some of his drawings. As he put it, 'By the merest chance I happened to have some of my best drawings with me, and I asked him to look at them and give me his opinion.' That opinion was: 'There is no doubt about your gift. One day you will most assuredly paint very great and beautiful pictures...' Burne-Jones was as perceptive as he was generous towards the young boy whose work was still barely more than a pallid imitation of his own. In one respect, though, he was not quite right. Beardsley would create great art but would not paint great pictures by means of brush and paint. Burne-Jones had a typically *fin-de-siècle* love of the rich, decorative properties of painting and of a lovely densely-worked paint surface – what Gustave Moreau would have termed *la richesse nécessaire*. It is not the least remarkable aspect of Beardsley's genius that he was able to achieve *la richesse nécessaire* in simple black and white and through the seemingly unpromising medium of photo-mechanical reproduction.

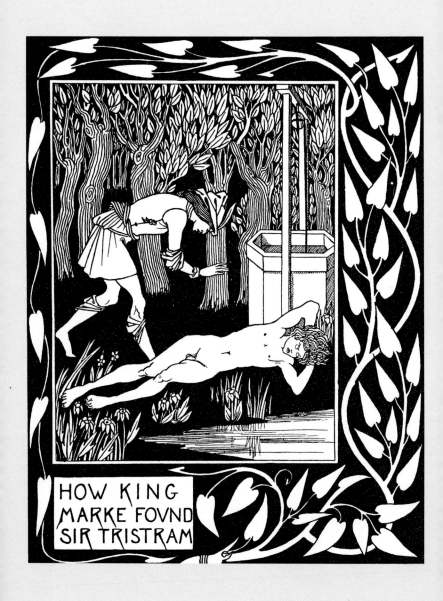

15. Beardsley, How King Marke found Sir Tristram, from *Le Morte D'Arthur.*

Burne-Jones was at the height of his fame in 1891. Two years earlier his mural-sized painting of *King Cophetua and the Beggar Maid* had been awarded a gold medal at the 1889 World Exhibition in Paris. He was embraced by French Symbolist artists such as Gustave Moreau and Puvis de Chavannes as one of their own, and his art was seen as an antidote to the crass materialism of the ninteteenth century, as represented by the newly-constructed Eiffel Tower for Parisians, and in his own mind perhaps by the ugliness and squalor of the industrial city of Birmingham, where he had spent his sad and loveless childhood Burne-Jones created a perfectly beautiful dream-world as unlike nineteenth-century Birmingham as possible. This world is people with androgynous neurasthenics who are all perfectly beautiful but seem neither happy nor healthy, with their pallid faces, bruised eyes, haunted expressions and hunched and furtive body language. Beardsley seized upon and exaggerated to the point of caricature all the more *fin-de-siècle* features of Burne-Jones' art, as can be seen in his first published drawing *Hamlet Patris Manem Sequitur* of 1891. The extraordinarily elaborate pen and ink drawing entitled *Siegfried, Act II*

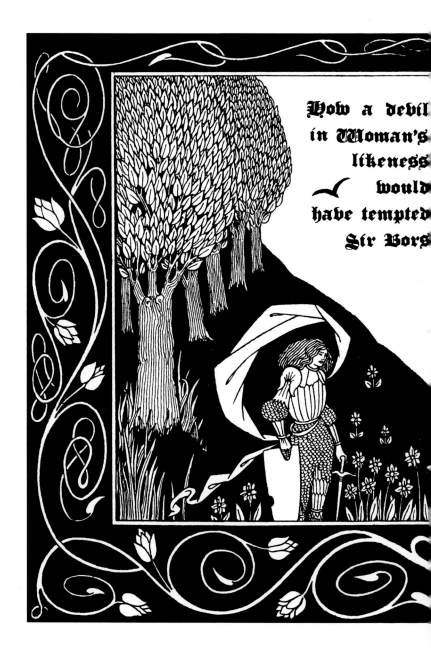

How a devil in Woman's likeness would have tempted Sir Bors

16. Beardsley, How a Devil in Woman's Likeness Would Have Tempted Sir Bors, from *Le Morte D'Arthur*.

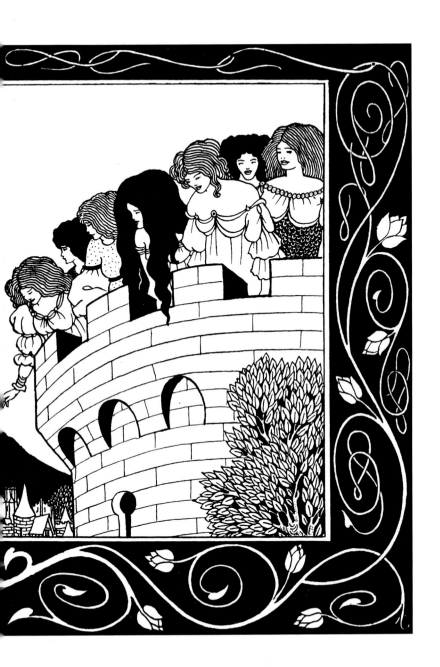

that Beardsley presented to Burne-Jones in gratitude for his support, shows the young artist already straying beyond the confines of latter-day Pre-Raphaelitism and combining playful Japonaiserie with elements drawn from Mantegna. Beardsley's spindly-limbed Siegfried with his effeminate Pre-Raphaelite facial features and dark curly hair could hardly be further from the thuggishly Teutonic hero of Wagner's opera, but the drawing pleased Burne-Jones sufficiently for him to hang it amongst his treasured Dürer woodcuts. It was not long, though, before the mutual admiration between Burne-Jones and Beardsley cooled as the younger artist embarked upon his first major commission – five hundred illustrations for an edition of Malory's *Le Morte D'Arthur*, published by J. M. Dent in direct competition with the lavishly illustrated books produced by Burne-Jones and William Morris at the Kelmscott Press.

17. Edward Burne-Jones, *The Perseus Series: The Baleful Head*, 1885. Gouache, 153.7 x 129 cm. City of Southampton Art Gallery, Southampton.

18. Beardsley, *Siegfried*, Act II, 1892. Victoria and Albert Museum, London.

As boredom set in with this seemingly endless commission, Beardsley slipped into parody of the earnest medievalism of the Pre-Raphaelites. Even in the earliest illustration the pronounced chin of the Pre-Raphaelite facial type is exaggerated to the point of caricature. Later, the blurring of gender and the profusion of hair found in Pre-Raphaelite art are taken to playful extremes in illustrations that hover between homage and parody of Burne-Jones and Rossetti. In the illustrations to the story of Isoud and Tristram, the genders of the lovers are hardly differentiated. They compete with each other in the volume of their hair. These illustrations are very much as Mario Praz described the paintings of Gustave Moreau. 'Lovers look as though they were related, brothers as though they were lovers, men have the faces of virgins, virgins of youths. The symbols of good and evil are entwined and equivocally confused.'

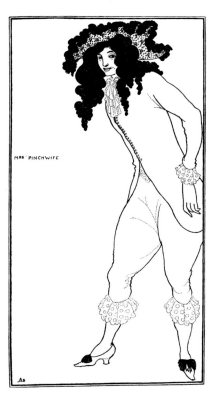

MRS PINCHWIFE

19. Beardsley, Mrs Pinchwife, from Wycherley's *The Country-Wife*.

20. Dante Gabriel Rossetti, *La Pia de' Tolomei*, 1868–80. Oil on canvas, 104.8 x 120.6 cm. Spencer Museum of Art, University of Kansas.

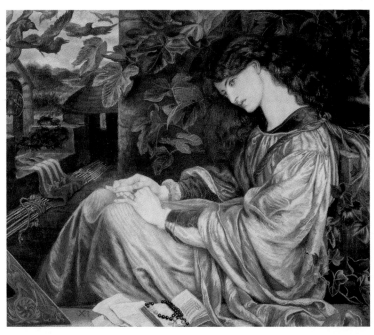

HAIR AND
DANTE GABRIEL ROSSETTI

In the 1890s there was an extraordinary pre-dilection for female hair in the work of artists of Symbolist or Art Nouveau tendencies. Female hair was depicted as a weapon of seduction and destruction. In Waterhouse's *La Belle Dame sans Merci* of 1893, the seductress quite simply wraps her long hair around the neck of the hapless knight. In the various versions of Munch's *Vampire* from 1893 onward, a male victim is engulfed in streams of blood-red hair. Stylized women's hair invades the entire world like some monstrous plant from science fiction in works by Jan Toorop such as *The Three Brides*. Mucha's poster for Job Cigarettes of 1896 irreverently subverts the Pre-Raphaelite ideal of female beauty, much as Beardsley did himself. Barely concealing his theft from Rossetti's *Beata Beatrix* by reversing the image, Mucha transforms Rossetti's image of ecstasy and death into one of a quick hit of pleasure from a longed-for cigarette. The girl's tentacular hair has a life of its own, apparently ready to reach out and grab the first male victim to pass by.

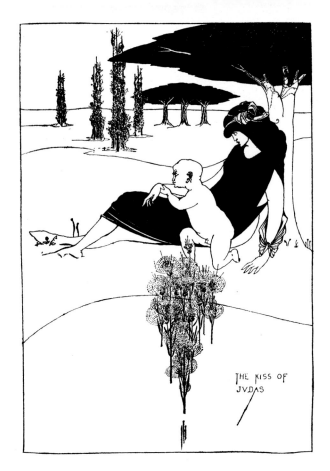

THE KISS OF
JVDAS

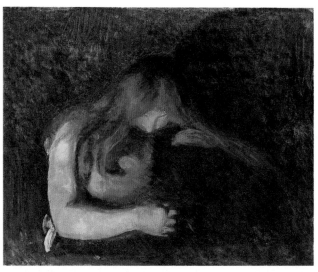

21. Beardsley, *The Kiss of Judas*, published in the *Pall Mall Magazine*, 1893. Pen, ink and wash. Victoria and Albert Museum, London.

22. Edvard Munch, *Vampire*, 1895. Lithograph, 38.2 x 54.5 cm. Munch Museum, Oslo.

23. Beardsley, chapter-heading from *Le Morte D'Arthur*.

Famous literary examples of hair fetishism in the 1890s include the scene from Maeterlinck's play *Pelléas et Mélisande* in which Melisande smothers Pelleas in her hair as she leans towards him out of her bedroom window, and Pierre Louÿs' erotic poem *La Chevelure*, both memorably set to music by Debussy, and Georges Rodenbach's novel *Bruges-la-Morte*, in which the hero strangles his mistress with the hair of his dead wife. Beardsley takes up this *fin-de-siècle* theme of 'voluminous hair' but with his usual admixture of irony and mockery. His women's hair tends to be grotesque rather than seductive or threatening. The hirsute ladies who lean over the castle battlements in the illustration *How a Devil in a Woman's Likeness Would Have Tempted Sir Bors* produce an irresistibly comic effect as they attempt to entice the effete-looking Sir Bors with his swinging, child-bearing hips, who sports a similarly exaggerated hair-do. Slightly more threatening is a chapter-head in which masklike female faces are surrounded by halos of stylized hair that fill the entire picture space in the manner of Toorop.

24. Dante Gabriel Rossetti, *Beata Beatrix*, 1872. Oil on canvas,
87.5 x 69.3 cm. Art Institute of Chicago.

Like so much in *fin-de-siècle* art, this hair fetishism can be traced back to Burne-Jones' mentor Dante Gabriel Rossetti, whose obsession with women's hair bordered on the pathological. There are many accounts of Rossetti's following women in the street as though mesmerised by their hair. The distinguished Victorian novelist Mrs Gaskell described how Rossetti broke off in mid-conversation when a woman with beautiful hair entered the room, concluding that if Rossetti was not 'mad as a March hare', he was certainly 'hair mad'. The famous story of how Rossetti buried the manuscripts of his poems in his wife's hair that later had to be cut away when attempts were made to retrieve them from the coffin for publication, must have added a considerable frisson to the mystique of women's hair in Pre-Raphaelite circles.

Beardsley's most direct homage to Rossetti (though as always tinged with an element of parody) was the sinister illustration entitled *The Kiss of Judas* that he contributed to the *Pall Mall Magazine* in 1893, in which a sultry beauty – clearly based on Rossetti's depiction of his second great love Jane Morris as 'la Pia de' Tolomei' – seems weighed down by the sheer bulk of her massed dark hair.

25. Beardsley, suppressed frontispiece for *An Evil Motherhood*,
by Walt Ruding.

BEARDSLEY
AND SALOMÉ

I t was in 1893 that the 21-year-old Beardsley
achieved worldwide fame through an article
entitled modestly 'A New Illustrator' in the
first issue of the art magazine *The Studio*. The
1890s was a golden age for art magazines,
thanks largely to advances in the technology of
illustration. *The Studio* was relatively cheaply
produced and far less lavish and beautiful than
La Revue Blanche in Paris, *Pan* in Berlin and *Ver
Sacrum* in Vienna, but achieved a far wider cir-
culation and much greater international influ-
ence than any other art magazine of the period.
The successful launch of *The Studio* owed much
to the sensational impact of the article on
Beardsley by Joseph Pennell. Among the pictures
accompanying the article were one of the earlier
illustrations to *Le Morte D'Arthur*, still very
much indebted to Burne-Jones' work for the
Kelmscott Press, and the *Siegfried* that Beardsley
had presented to Burne-Jones.

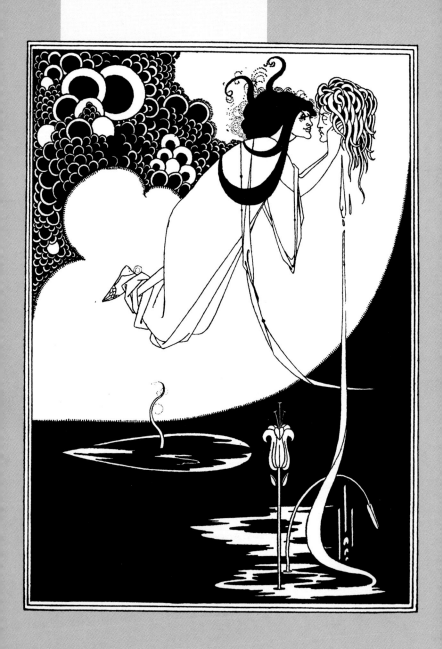

26. Beardsley, The Climax, from *Salomé*.

The most startlingly novel piece, though, was an illustration to Oscar Wilde's play *Salomé* that had just been published in Wilde's original French but still awaited publication in an English translation. Despite Salome's pronounced chin and tentacular hair, this drawing announced very clearly that Beardsley had left Pre-Raphaelitism behind and found new artistic allegiances in Whistler and Japanese prints. He was also staking a strong claim to illustrate the forthcoming English edition of Wilde's sensational play. The month before *the Studio* article appeared, Wilde sent Beardsley a copy of the French edition of *Salomé* inscribed 'March '93. For Aubrey; for the only artist who, besides myself, knows what the Dance of the Seven Veils is, and who can see that invisible dance. Oscar.'

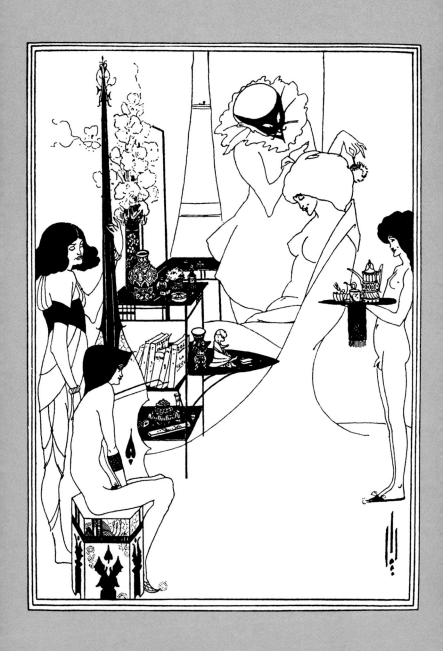

27. Beardsley, The Toilet of Salome, first version (uncensored).

Salome – who, prompted by her mother Herodias, demanded the head of John the Baptist as a reward for dancing before Herod – merited hardly more than a passing reference in the New Testament but exercised an extraordinary fascination on the artists, writers and composers of the late nineteenth century. It was the French Symbolist painter Gustave Moreau who established Salome as the quintessential *femme fatale* with two paintings that he exhibited at the Paris Salon in 1876. These were described in a celebrated passage in Joris-Karl Huysmans' notorious novel *A Rebours* ('Against Nature') published in 1884, which in turn provided inspiration for both Wilde and Beardsley.

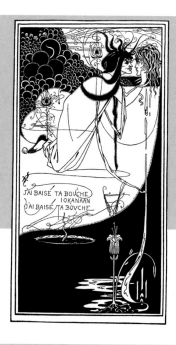

J'AI BAISÉ TA BOVCHE
IOKANAAN
J'AI BAISÉ TA BOVCHE

28. Beardsley, J'ai baisé ta bouche, Iokanan, illustration to *Salomé* by Oscar Wilde, published in *The Studio*, Vol.1, No. 1, 1893.

29. Beardsley, The Entrance of Herodias, from *Salomé*, with Wilde caricatured as her jester. Uncensored version, 1894.

Here she was no longer just the dancing-girl who extorts a cry of lust and lechery from an old man by the lascivious movements of her loins; who saps the morale and breaks the will of a king with the heaving of her breasts, the twitching of her belly, the quivering of her thighs. She had become, as it were, the symbolic incarnation of undying Lust, the Goddess of immortal Hysteria, the accursed Beauty exalted above all other beauties by the catalepsy that hardens her flesh and steels her muscles; the monstrous Beast, indifferent, irresponsible, insensible, poisoning – like the Helen of ancient myth – everything that approaches her, everything that she touches.

The intense misogyny of this passage is expressed even more plainly in Moreau's own words about another of his countless images of Salome.

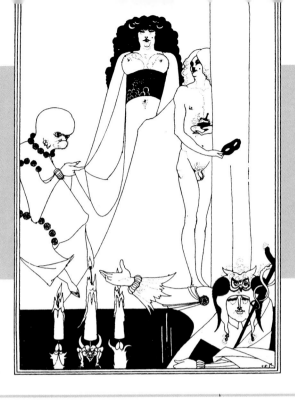

This bored and whimsical woman indulges her lower nature by giving herself the pleasure of seeing her enemy struck down – not a particularly keen pleasure for her, because she is weary of having all her desires satisfied. This woman walks nonchalantly in the primal manner of an animal through the gardens that have just been marred by a gruesome murder, a murder sufficiently horrible to frighten the executioner himself and to make him flee in mindless terror. When I want to represent such fine nuances, I do not look to find them in the subject but in the nature of women in real life – women who actively seek unhealthy emotions and are too stupid even to understand the horror in the most appalling situations.

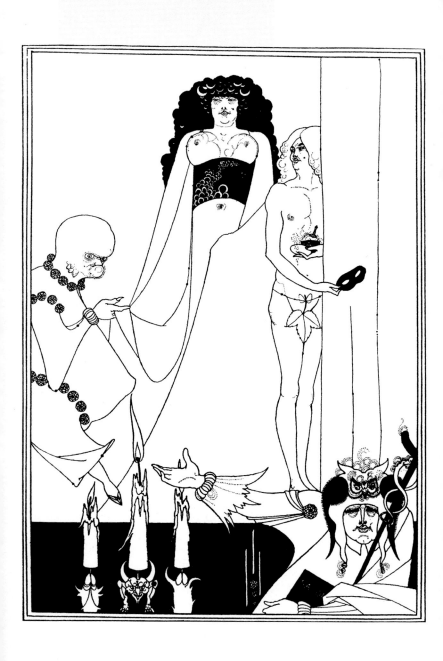

30. Beardsley, The Entrance of Herodias, from *Salomé*, 2nd version.

Gustave Moreau was a classic case of a mother-fixated misogynist, the 'Norman Bates' of nineteenth-century art, living alone with his aged mother in their gloomy Parisian mansion. When she became deaf, he communicated with her by means of little scraps of paper, and after her death he closed off her bedroom and the dining-room in which they had eaten together.

Beardsley was also in thrall to a domineering mother – more so, perhaps, as she took on the double role of mother and nurse as he succumbed to the ravages of tuberculosis. Beardsley's hostility to women may be detected not only in the *Salomé* illustrations but also in such harsh images as his illustration to *An Evil Motherhood* and his depictions of Messalina.

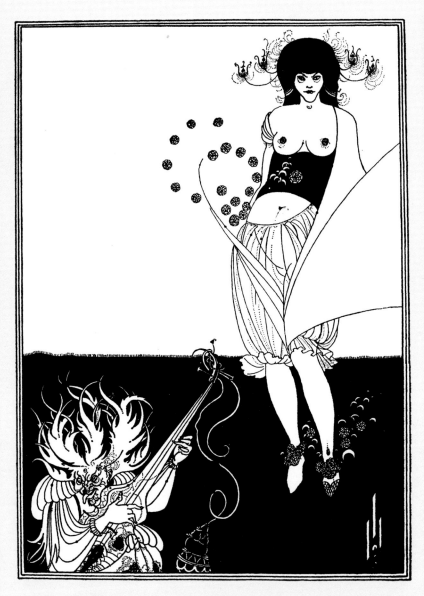

31. Beardsley, The Dance of the Seven Veils, from *Salomé*.
Following page :
32. Gustave Moreau, *Salomé, or Tatooed Salome*, 1876. Musée
 Gustave Moreau.

Soon after the appearance of the Salomé illustration in *The Studio* in April 1893, Beardsley was indeed invited by the publisher John Lane to provide ten illustrations for the new translation of Salomé at the handsome fee of fifty guineas. From the first, the prestigious commission was fraught with difficulties. Beardsley became involved in the quarrels surrounding the inept translation of the original French text by Wilde's lover Lord Alfred Douglas, tactlessly offering to come up with a better translation of his own. The stresses of the collaboration mark the beginning of the long deterioration in relations between Wilde and Beardsley. Writing to their mutual friend Robert Ross, Beardsley exclaimed, 'I can tell you I had a warm time of it between Lane and Oscar and Co. For one week the number of telegraph and messenger boys who came to the door was simply scandalous.' The comment was perhaps intended to be less malicious than it sounds in the light of the revelations at Wilde's trial for homosexuality two years later, but Beardsley concluded that both Wilde and his lover were 'really dreadful people'.

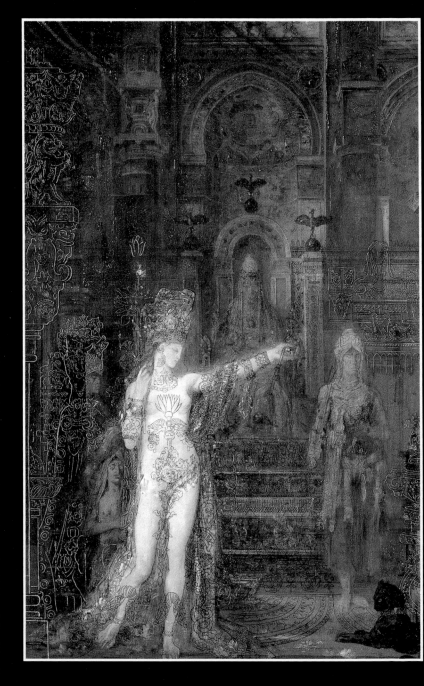

Beardsley openly mocked Wilde in the *Salomé* illustrations by caricaturing his bloated face as 'the woman in the moon'. Brilliantly economical and immediately recognisable, this cruel lampoon of Wilde may have been based on an affectionately-inscribed photo that Wilde had earlier presented to the artist. It makes an interesting comparison with the portraits of Wilde executed by Toulouse-Lautrec who observed Wilde during the trial the following year. Wilde himself dismissed Beardsley's illustrations to his play as 'the naughty scribbles of a precocious schoolboy'. There was indeed always an element of the naughty schoolboy in Beardsley. In a letter written in February 1893 to an old school friend he boasts that his illustrations to Lucian's *True Histories* are 'most certainly the most extraordinary things that have ever appeared in a book both in respect to technique and conception. They are also the most indecent.'

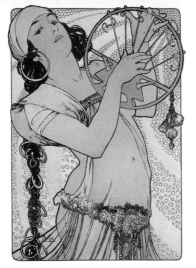

From now on Beardsley would wage a war with his publishers by pushing at the boundaries of the permissible and also by trying to slip hidden 'indecencies' past their censorious eyes. John Lane objected to several of the illustrations submitted for *Salomé*. He vetoed, for instance, the exposed genitalia of the effeminate page-boy in *Enter Herodias*. Beardsley covered the offending parts with a jokey figleaf suspended from a g-string that looks far more indecent than the original nudity. On a proof of the uncensored version Beardsley inscribed a plaintive rhyme.

Because one figure was undressed
This little drawing was suppressed.
 It was unkind,
 But never mind –
Perhaps it all was for the best.

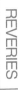

No doubt Beardsley revelled in Lane's
failure to spot the outrageously phallic form of
the candlesticks in the foreground and the
monstrous erection that lifts the garment of
Herodias' dwarf.

Beardsley's first version of *The Toilet of
Salome* was rejected outright. Here the nudity of
the little hermaphrodite serving coffee was the
least of the problems. From the placing of their
hands it seems that both Salome herself and one
of her page-boys are lost in masturbatory rev-
erie. Most offensive of all to nineteenth-century
morality was the tiny tuft of pubic hair peeking
out from between the legs of the seated youth.
(The ban on the sight of pubic hair in movies
would not be lifted in Britain until the 1970s!)
The wonderfully spare and elegant re-submitted
version of *The Toilet of Salome* also sports some
subversive touches, such as the name of Zola
and the Marquis de Sade on the spines of books
on Salome's dressing-table.

34. Beardsley, The Woman in the Moon, from *Salomé*
(frontispiece), 1894.

Beardsley's Salomé illustrations outraged and provoked every bit as much as either Beardsley or Wilde could have hoped. A writer in *The Times* found the *Salomé* illustrations 'fantastic, grotesque, unintelligible for the most part, and so far as they are intelligible, repulsive'. *The Times* writer had in fact hit upon an aspect of the *Salomé* illustrations that cannot have pleased Wilde – their near-total irrelevance to the text. Several of the illustrations do not seem to have any connection at all with incidents in the play. Throughout, Beardsley displays an insouciant delight in the most *outré* anachronisms, such as the elegant modern furniture and the French novels in *The Toilet of Salome*, and in the pervasively Japanese style that was hardly suitable for the Biblical setting of the story.

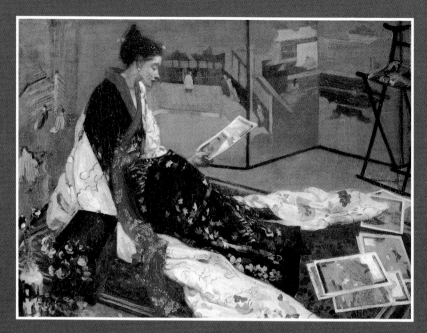

35. Whistler, Lemon and Turquoise : The Japanese Dress.

36. Japanese eroticism.

JAPANESE
INFLUENCES

S ince United States battleships forced Japan at gunpoint to trade with America in 1853, Japanese wood-block prints had flooded the West. Over two generations, from the 1860s to the 1890s, Japanese prints provided vital inspiration in the early heroic stages of modern art. Artists who questioned and broke with the principles that had governed Western art since the Renaissance found nourishing alternatives in Japanese art. What Beardsley described as his 'Jap manner' encompassed 'Japonaiserie' (the use of exotic and decorative motifs) and also 'Japonisme' (the use of Japanese design principles). The former – often derived at second hand from Japanese art via Whistler's *The Peacock Room*, to which a youthful Beardsley and Mabel had paid a pilgrimage in 1891 – can be seen in the first of Beardsley's *Salomé* designs published in *The Studio*, and even more blatantly in the illustration entitled *The Peacock Skirt*. Japonisme can be seen in the stark and abstracted elegance of the second version of *The Toilet of Salome*, with its large areas of empty space.

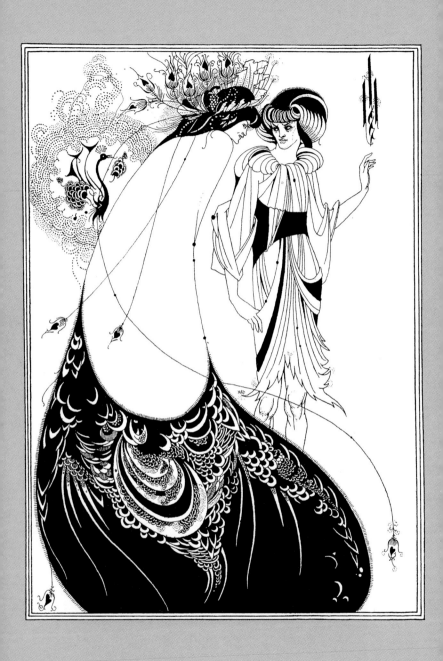

37. Beardsley, The Peacock Skirt, from *Salomé*.

Japanese art would also provide a powerful in-
spiration to Beardsley's later more explicitly ero-
tic illustrations. To those inured to the Western
tradition of coyly idealized and depilated nudity,
Japanese erotic prints with their minute exami-
nation of all the folds and wrinkles of pubic
flesh and curly hair are often so startling as to
be incomprehensible at first glance. Beardsley
was first introduced to such images by his artist
friend William Rothenstein. Rothenstein later
recounted how he had 'picked up a Japanese
book in Paris, with pictures so outrageous that
its possession was an embarrassment. It pleased
Beardsley, however, so I gave it to him. The next
time I went to see him, he had taken out the
most indecent prints from the book and hung
them around his bedroom.'

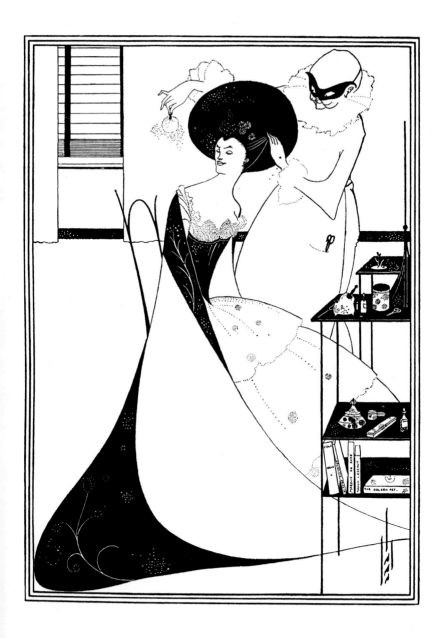

38. Beardsley, The Toilet of Salome, 2nd version.

39. James McNeill Whistler, the Peacock Room, as reconstructed in the Freer Gallery, Washington.

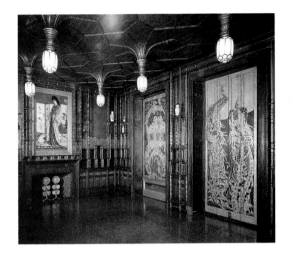

The German critic Julius Meier-Graefe, who would himself shortly lose the editorship of the avant-garde art magazine *Pan* for publishing in its pages an 'indecent' print by Toulouse-Lautrec, wrote:

At Beardsley's house one used to see the finest and most explicitly erotic Japanese prints in London. They hung in plain frames against delicately-coloured backgrounds, the wildest fantasies of Utamaro, and were by no means decent, though when seen from a distance delicate, proper and harmless enough. There are but few collectors of these things because they cannot be exhibited.

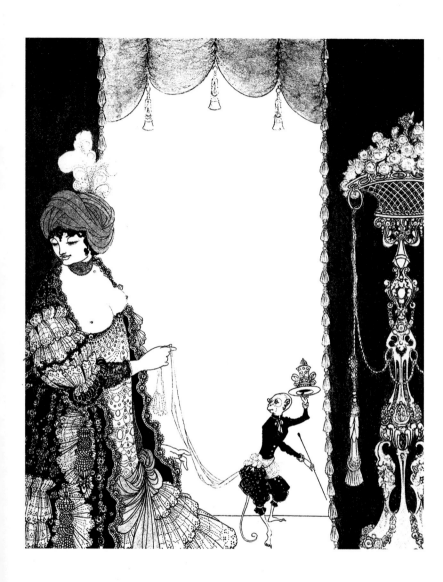

40. Beardsley, The Lady with the Monkey, 1897, from Six Drawings Illustrating Théophile Gautier's Romance *Mademoiselle de Maupin*. Victoria and Albert Museum, London.

BEARDSLEY
THE COSMOPOLITE

The house in which Beardsley exhibited these shocking images was 114 Cambridge St, in what estate agents called South Belgravia but what was actually the rather less-fashionable-sounding area of Pimlico. On the crest of the wave between the 1893 article in *The Studio* and the disastrous trials of Oscar Wilde in 1895, Beardsley and Mabel were able – supported through 1894 by a steady income from Beardsley's work in the highly successful *Yellow Book* – to acquire and live in a house of their own. Here for a little more than a year Beardsley was able to play the roles to which he most aspired: of aesthete and dandy.

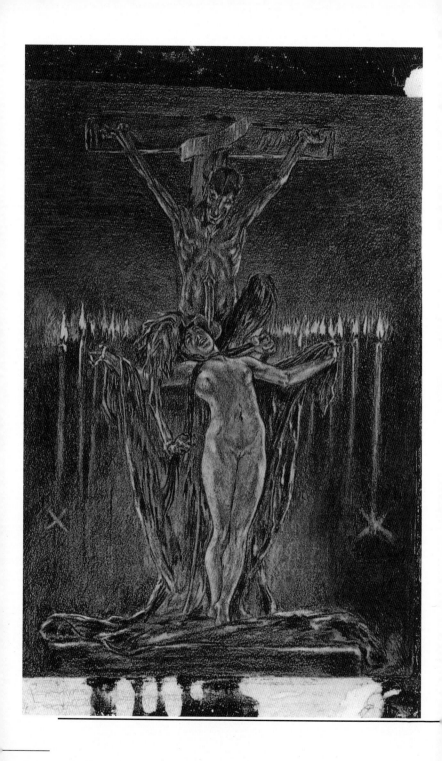

Though apparently still too young to be a lease-holder (the house was taken on in the name of the older Mabel), Beardsley had travelled an immense distance artistically and socially since, as a shy and gawky youth, he had paid his first visit to Burne-Jones. The former clerk still in his early twenties was well able to hold his own against the merciless wit and formidable egos of men such as Oscar Wilde and James McNeill Whistler. One of Wilde's nastiest quips was 'Yes, dear Aubrey is almost too Parisian; he cannot forget that he has been to Dieppe – once.'

Beardsley's first trip abroad was in fact to Paris in 1892, paid for with money inherited from his great-aunt in Brighton. He did indeed have a fondness for Dieppe, and visited many times. Perhaps as a seaside resort it reminded him of his home town of Brighton. It was also a somewhat sleazy area, full of disgraced Britons – divorced women and gentlemen anxious to avoid the draconian British laws against homosexuality. Wilde himself would eventually find himself in Dieppe after his release from Reading prison, and it was there that he had his last sad meetings with Beardsley.

41. Felicien Rops, *Le Calvaire* from *Les Sataniques series*, 1882. 26 x 17 cm. Antwerp.

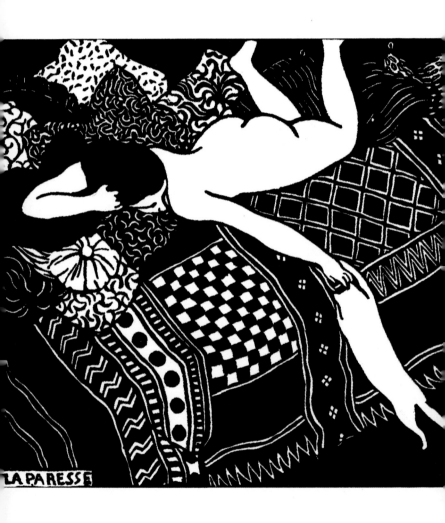

42. Félix Vallotton, *Intimités*: La Paresse, 1896.

Wilde was right about Beardsley to the extent that his veneer of sophistication was decidedly French-influenced. From a very early age Beardsley devoured French literature in the original language. At the age of eighteen he could boast 'I can read French now almost as easily as English.' His concept of the artist as dandy was derived directly or indirectly via Manet, Degas and Whistler, and from Baudelaire's 1863 essay 'The Painter of Modern Life'. But the book that influenced Beardsley most of all was Huysmans' novel *A Rebours* ('Against Nature') published in 1884, which rapidly became a cult text for *the fin-de-siècle* artists, by whom it was dubbed 'the Bible of Decadence'. Beardsley adopted the startling orange and black colour scheme of Des Esseintes' house in *A Rebours* for his own house in Pimlico. He also took on the preciousness of the novel's aristocratic hero, becoming, as one observer put it, 'a model of daintiness in dress, affected apparently for the purpose of concealing his artistic profession'. 'I caught cold', he was heard to murmur, 'by going out without the tassel on my walking stick.'

AUBREY
BEARDSLEY.

43. Aubrey Beardsley, *Self-Portrait*, 1892. Ink drawing.

THE OSCAR WILDE
FIASCO

The Pimlico house, his elegant lifestyle and the Thursday-afternoon At-Homes in which he and Mabel received fashionable artistic society all had to be given up with brutal rapidity in the wake of the Oscar Wilde trials in the spring of 1895. Early in the year, the Marquis of Queensberry – father of Wilde's lover, Lord Alfred Douglas – left a visiting-card at Wilde's club addressed to 'Oscar Wilde, posing Somdomite' (literacy was evidently not his strong point). Urged on by his irascible lover, Wilde rashly sued the Marquis for libel, and lost. This automatically opened the way for his prosecution for homosexual acts. Wilde's condemnation to two years of hard labour triggered an ugly moral backlash and brought to an end Beardsley's brief period of success and prosperity. As he was arrested, Wilde was spotted carrying a yellow book – in fact a yellow-backed French novel, but reported in the press as *The Yellow Book*. That reference and Wilde's and Beardsley's erstwhile collaboration on *Salomé* were enough to besmirch Beardsley in the scandal, despite the facts that Beardsley and Wilde were no longer on very friendly terms, that Wilde had never contributed to *The Yellow Book*, and that Beardsley most probably did not share Wilde's sexual proclivities.

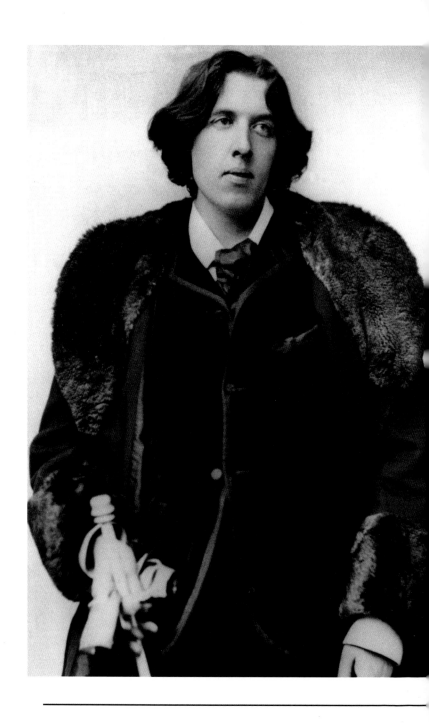

Hostile stone-throwing mobs gathered outside the offices of *The Yellow Book*'s publisher John Lane, and several of Lane's authors – fearful for their own reputations – demanded Beardsley's dismissal. Overnight from being the illustrator most in demand, his name had become a byword for degeneracy: he was at once almost unemployable.

44. Photograph of Oscar Wilde. Photographer unknown.

The Yellow Book

An Illustrated Quarterly

Volume V April 1895

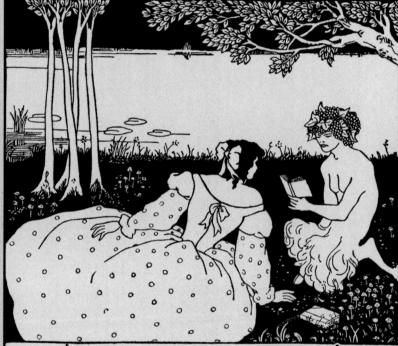

Price
$1.50
Net

London: John Lane
Boston: Copeland & Day

Price
5/-
Net

SEX AND
SEXUAL IMAGERY

Exactly what Beardsley's sexual orientation was has remained a much-debated mystery. Beardsley certainly had a wide-ranging fascination for sexual activities and for deviations of every kind, from flagellation and transvestism through to bestiality. (His unfinished fantasy novel *Under the Hill* lovingly describes Venus masturbating her pet unicorn before breakfast.) There are unsubstantiated rumours and theories that Beardsley was involved in an incestuous relationship with his sister Mabel. The sexual symbolism of the monogram he used on all his mature work – in the words of Brigid Brophy, 'a line penetrating between two lines and dissolving into drops, ... a diagram of sexual penetration and ejaculation' – suggests that he defined and identified himself in sexual terms.

45. Beardsley, frontispiece of *The Yellow Book*, 1895.

46. Beardsley, frontispiece of *The Savoy*, No 1, depicting a
cherub urinating on a copy of *The Yellow Book*, 1895.

THE SAVOY

There were those, though, like George Bernard Shaw, who believed that Beardsley was a 'reveller in vices of which he was innocent', and that his tubercular condition prevented more than a voyeuristic interest in sex. It was an impression that he was at some pains to deny. Replying to a comment in the press that he was 'sexless and unclean', he wrote 'As to my uncleanliness, I do the best for it in my morning bath, and if [the critic] has really any doubts as to my sex, he may come and see me take it.'

Though he took on so many mannerisms of Wilde's homosexual coterie, he did not apparently emulate all their activities. The poet W. B. Yeats recalled the artist looking in the mirror and muttering 'Yes, yes – I look like a sodomite, ...But no, I am not that.' A joking reference in a letter of 1893 from Beardsley to John Lane that he would be going out 'dressed as a tart' has lead to speculation about a taste for cross-dressing, of which there are certainly many examples in his work, both male and female.

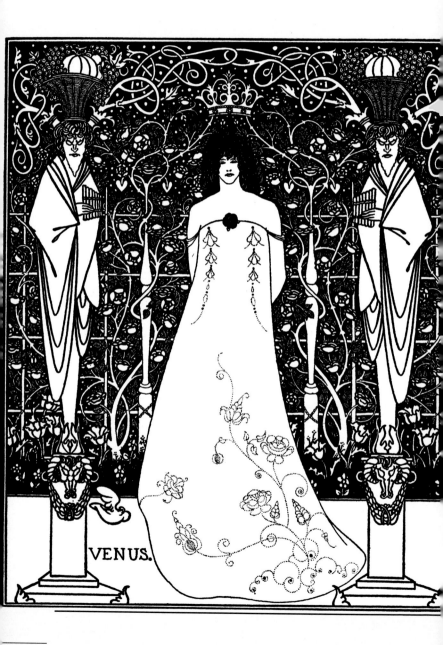

VENUS.

Ironically, it was the loss of his position with *The Yellow Book*, and the consequent loss of a regualr income, that led to the very much more explicitly erotic illustrations of Beardsley's last years. Beardsley's unemployed and virtually unemployable state forced him (metaphorically) into the arms of Leonard Smithers, a dealer in rare erotica and publisher of limited editions of books that could not be put on the open market – and a man who was described by Wilde as 'the most learned erotomaniac in Europe'. Smithers was certainly a character of dubious reputation but also of courageous unconventionality, prepared to take on Wilde's *The Ballad of Reading Gaol* when no other publisher would touch it. Without Smithers we would not have some of Beardsley's most remarkable works.

47. Beardsley, frontispiece for *Venus and Tannhäuser*, 1895.

With what must have seemed foolhardiness to many at the time, Smithers launched a new periodical called *The Savoy* that attempted to reclaim the aesthetic ground given up by *The Yellow Book*, and to provide a showcase for Beardsley's discredited talents. But even Smithers balked at Beardsley's first cover design, which showed a cherub urinating on a copy of *The Yellow Book*. Beardsley's design for a prospectus for *The Savoy* also caused problems. When Smithers objected that Beardsley's first design of a pierrot was too effete and frivolous for John Bull's taste, Beardsley replaced the pierrot with a corpulent John Bull. No one seems to have noticed till too late that Beardsley's John Bull displayed a small but conspicuous erection under his breeches. It was hoped that Smithers would eventually

publish Beardsley's erotic novel *Under the Hill*. This unfinished novel – based on the 16th-century ballad about Venus and Tannhäuser that had already inspired Swinburne's poem *Laus Veneris*, one of the most beautiful paintings by Burne-Jones, and Wagner's opera *Tannhäuser* – is a masterpiece of self-conscious *fin-de-siècle* decadence. Beardsley's finely-wrought text exhibits not only a curiosity about every imaginable form of human sexuality but also a love of artifice and a fascination with sickness and with strange combinations of the macabre and the exquisite, of the kind we also see in the mottled and iridescent surfaces of Art Nouveau ceramics and glass, and in the sinister jewellery of René Lalique.

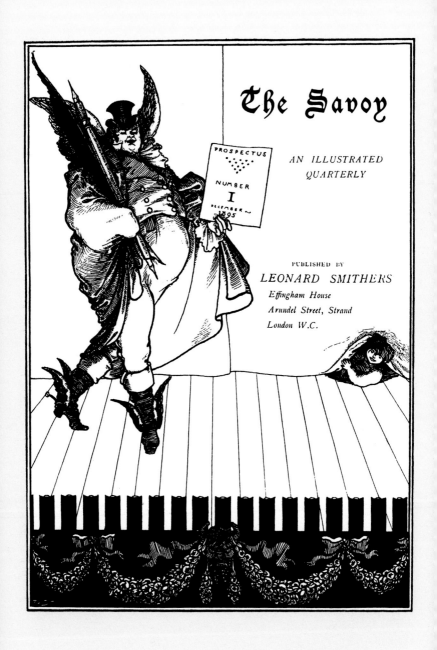

The Savoy

AN ILLUSTRATED
QUARTERLY

PUBLISHED BY
LEONARD SMITHERS
Effingham House
Arundel Street, Strand
London W.C.

48. Beardsley, revised prospectus for *The Savoy*, December 1895.

The Savoy

REVERIES

Huysman's *A Rebours* was clearly the point of departure for Beardsley's elaborately descriptive style in *Under the Hill*. We find the same aestheticizing of disease in both novels. In *Under the Hill* Beardsley gives a description of the revellers' costumes: 'There were spotted veils that seemed to stain the skin with some exquisite and august disease... But most wonderful of all were the black silhouettes painted upon the legs, and which showed through a white silk stocking like a sumptuous bruise.' In *A Rebours* Huysmans' hero Des Esseintes delights in the artificial and monstrous-looking plants.

'These plants are really astounding,' he said to himself, stepping back to appraise the entire collection. Yes, his object had been achieved; not one of them looked real; it was as if cloth, paper, porcelain and metal had been lent by man to Nature to enable her to create these monstrosities. Where she had not found it possible to imitate the work of human hands, she had been reduced to copying the membranes of animal's organs, to borrowing the vivid tints of their rotting flesh, the hideous splendours of their gangrened skin. 'It all comes down to syphilis,' Des Esseintes reflected, as his gaze was drawn and held by the horrible markings of the caladiums over which a shaft of daylight was playing.

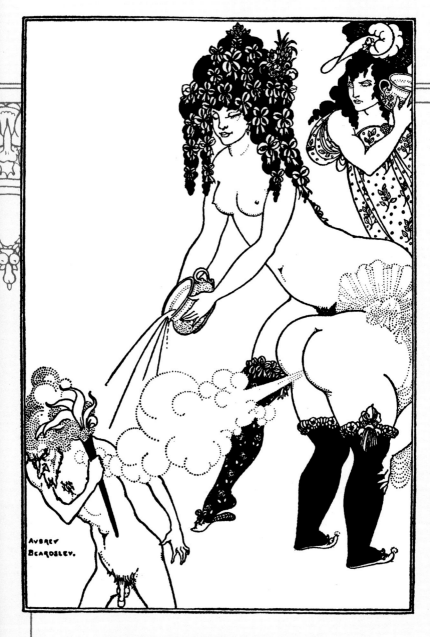

49. Beardsley, Lysistrata Defending the Acropolis.

50. Beardsley, front cover of *Lysistrata*.

In 1896 Smithers commissioned Beardsley to illustrate *Lysistrata*, Aristophanes' bawdy play about a sex strike in ancient Athens and Sparta. It was an inspired choice that led to one of Beardsley's greatest artistic achievements as well as to his most explicitly erotic illustrations. Appropriately for this ancient Greek subject, Beardsley drew upon his study of the Greek vases that had been so avidly collected by British aristocrats in the eighteenth century and of which the British Museum possessed an unrivalled collection. Julius Meier-Graefe discussed with Beardsley the vases that had most appealed to him and commented,

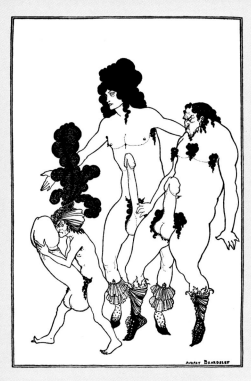

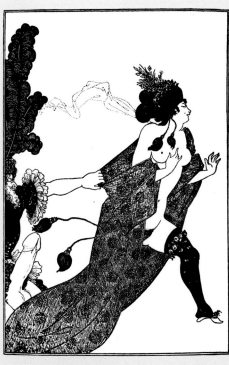

51. Beardsley, The
 Lacedaemonian
 Ambassadors.

52. Beardsley, Cinesias
 Entreating Myrrhina to
 Coition.

53. Beardsley, Lysistrata
 Haranguing the
 Athenian Women.

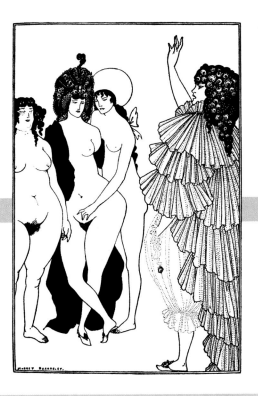

The side of them which we would prefer to see is generally turned to the wall, and in some cases the dainty details have been painted out by well-meaning guardians of public morals… It was here that Beardsley learnt the most precious secrets of his work, and certainly he had none of the prudishness of the curators. He owed it even more to the Greeks than to the Japanese that he had no need to be prudish and that the unrestrained eroticism of certain pages remains what it was intended to be, a device to intensify the rhythm. He loved both the Greeks and the Japanese, and his love was such that he attained in play what intellect fails to perceive and scholars regard as a regrettable aesthetic accident, accomplishing a union of the divided world which our historians do not like to mention in the same breath.

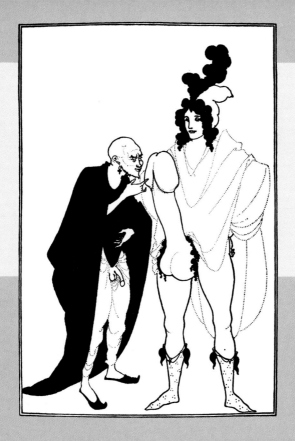

 As Beardsley was well aware, Whistler had in fact mentioned Japanese and Greek art in the same breath in the final lines of his influential *Ten o'Clock Lecture* in 1886: 'The story of the beautiful is already complete – hewn in the marbles of the Parthenon – and broidered, with the birds upon the fan of Hokusai – at the foot of Fusiyama.' Gauguin, who seems to have heard Whistler give his lecture in Dieppe in 1886, attempted to illustrate this idea in his very strange painting *Still-life with a Horse's Head* (also 1886). However, Gauguin's clumsy juxtaposition of a plaster-cast of the horse's head from the Parthenon frieze with a Japanese fan in a semi-pointillist style indebted to Seurat was far from the harmonious fusion of disparate cultures that Beardsley achieved in his Lysistrata drawings.

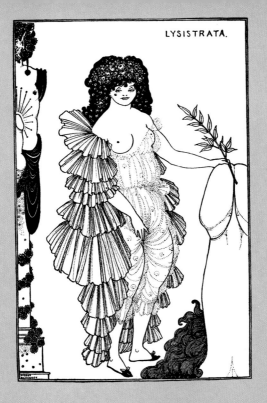

LYSISTRATA.

The most outrageous feature of the
Lysistrata drawings is Beardsley's depiction of
the enormously tumescent penises of the frus-
trated Greek men that dwarf even the most
extreme anatomical exaggerations of Utamaro.
Beardsley's phallic preoccupation – perhaps that
of a sick man who could no longer be sure of
achieving an erection – is apparent in a number
of joking references in his letters to Smithers.
After having a tooth removed he commented,
'Even my teeth are a little phallic', and included
a sketch of the tooth to prove it.

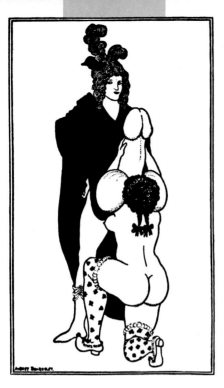

preceding page :
54. Beardsley, The Examination
of the Herald.

55. Beardsley, Lysistrata
Shielding Her Coynte.

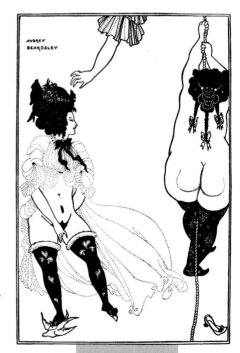

56. Beardsley, The penis
measures. Beardsley, 1896.

57. Beardsley, Two Athenian
Women in Distress.

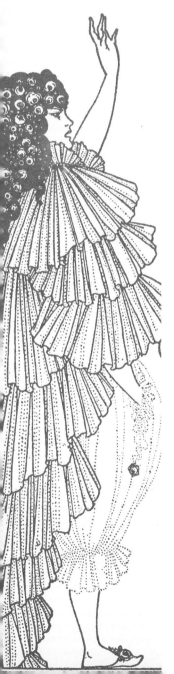

FINAL
PROJECTS

After *Lysistrata* there were
further projects for illus-
trated erotic books, inclu-
ding the Sixth *Satire* of Juvenal and
Les Liaisons Dangereuses, but
Beardsley did not live to complete
any of them. The illustrations of
Juvenal – especially *The Impatient
Adulterer* and *Bathyllus Posturing*
with his phallic gesture and apparent
invitation to buggery – surpass
those for *Lysistrata* in lubricity if
not in explicitness. There is a sense
that Beardsley, desperate for money
in his final illness may have been
pandering to the specialized tastes
of Smithers' clientele. In a letter of
1897 he asked Smithers plaintively,
'Do you want any erotic drawings?'

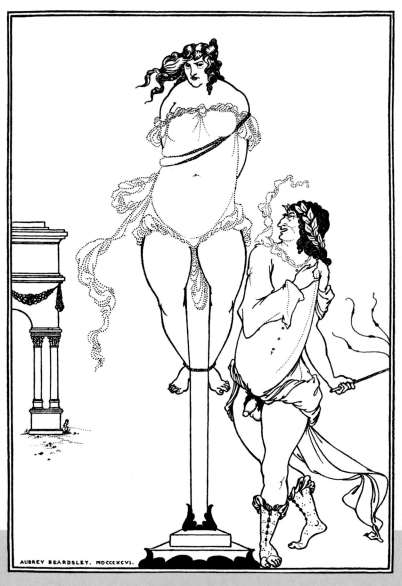

AUBREY BEARDSLEY. MDCCCXCVI.

58. Beardsley, *Juvenal Scourging a Woman*, 1900. Censored print.

59. Beardsley, Bathyllus Posturing, from the Sixth Satire of Juvenal, in An Issue of Five Drawings *Illustrative of Juvenal and Lucian*, published by Leonard Smithers, 1906.

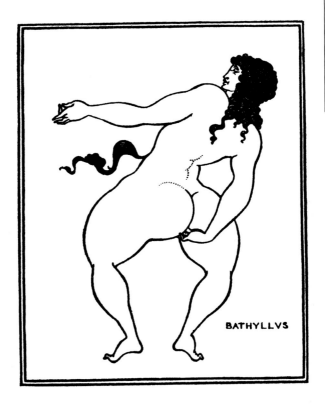

BATHYLLVS

Most terrible of all is the letter Beardsley wrote to Smithers on March 7, 1898, nine days before his death.

Dear Friend,
I implore you to destroy all copies of *Lysistrata* and bad drawings. Show this to Pollitt and conjure him to do same. By all that is holy, *all obscene* drawings.
In my death agony,
Aubrey Beardsley.

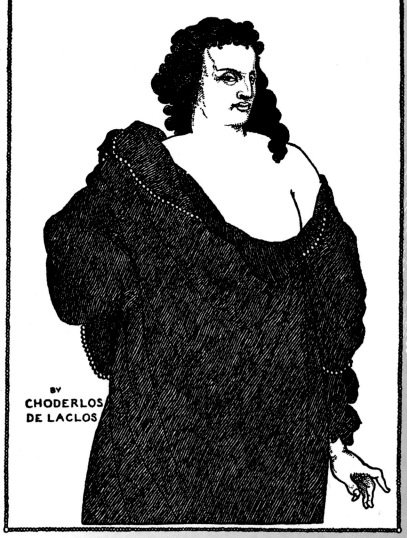

LES
LIAISONS DANGEREUSES.

BY
CHODERLOS
DE LACLOS

Had he been granted his full biblical span of three score years and ten, Beardsley would have survived well into the mid-twentieth century. His art in many ways defines the 1890s. It is hard to imagine what the Beardsley of the 1920s or the 1930s could have been like. Even in his short life Beardsley had shown a remarkable capacity to re-invent himself stylistically, and he would no doubt have done so again many times. Inevitably, the most perceptive and touching tribute to Beardsley was penned by his old friend and enemy Oscar Wilde in a letter of condolence to Smithers.

60. Beardsley, Count Valmont, frontispiece for *Les Liaisons Dangereuses*, by Choderlos de Laclos, 1896.

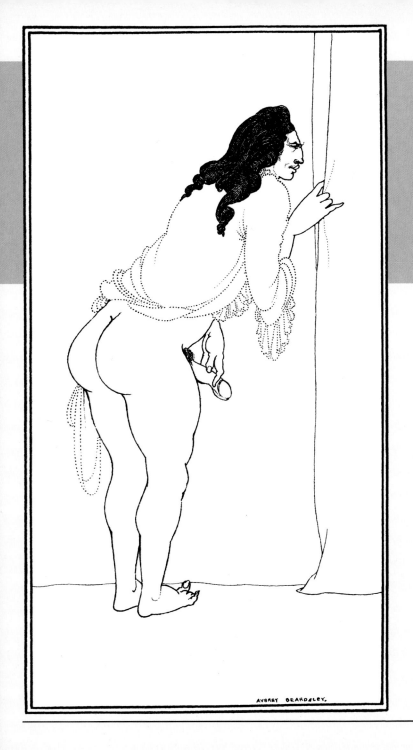

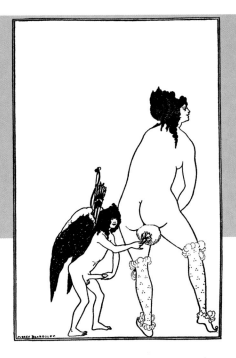

Superbly premature as the flowering of his genius was, still he had immense development, and had not sounded his last stop. There were great possibilities always in the cavern of his soul, and there is something macabre and tragic in the fact that one who added another terror to life should have died at the age of a flower.

61. Beardsley, *The impatient Adulterer*, 1896.

62. Beardsley, *The Toilet of Lampito*.

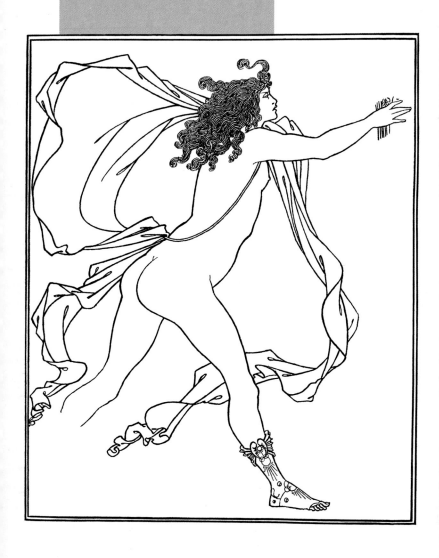

63. Beardsley, *Apollo in Pursuit of Daphne*, 1896.

64. Walter Richard Sickert, *Portrait of Aubrey Beardsley*, 1894.
Oil on canvas, 76.2 x 31.1 cm. Board of Trustees of the
Tate Gallery, London.

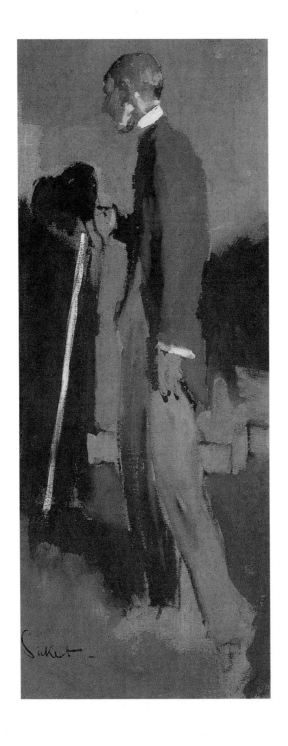

INDEX